Flash

Coloring in the Tattoo Style

CHRIS GARVER

Get Creative 6

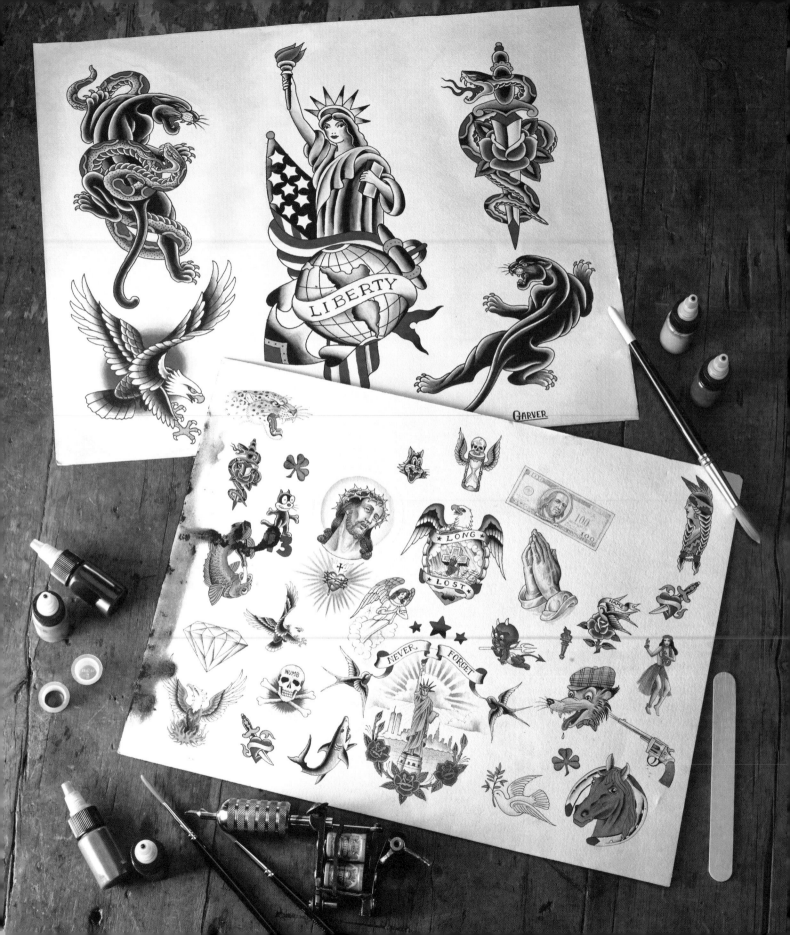

Introduction

The first time I stepped foot in a tattoo shop, I couldn't stop looking at the rows and rows of incredible designs that lined the walls. Sheet after sheet of eagles, snakes, skulls, and dragons were mixed with pin-ups, hearts, and flowers, and set in frames crowded together so closely that the room itself became a giant piece of art.

These sheets—called "flash"—serve as a sample gallery of motifs from which a customer can select a design to be tattooed. Usually several images are grouped on a single sheet, and are painted with intense black shading and bold colors to have a strong visual impact.

Later I learned that many of these eye-catching designs evolved over generations as artists copied, traced, or redrew popular images. Today it is not uncommon to see a pattern that originated in the nineteenth century that's been modified over and over to suit the tastes of each new era. Details such as hairstyles, typography, and clothing change, but the underlying motif remains the same. And because not every tattoo artist makes their own designs, new and classic flash can be purchased from tattoo suppliers or from other talented artists in the business, extending the reach of a particular design far beyond the walls of a single tattoo shop. Even with the rising popularity of custom tattooing, flash remains relevant both as an inspiration for a unique design for tattooing, and simply as beautiful pop art.

This book features takes on some of my favorite tattoo subjects that are rooted in classic designs but still fresh and new. I hope you enjoy coloring them as much as I have enjoyed drawing them.

— CHRIS GARVER

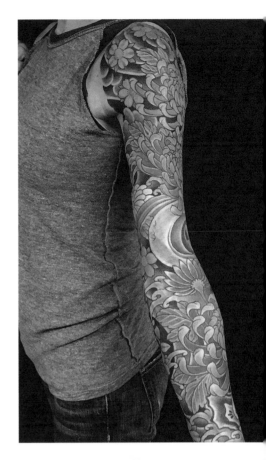

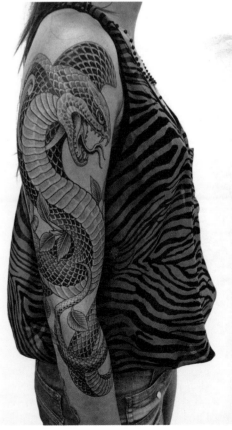

This book is dedicated to
Larissa Osby

About the Author

Well known and respected throughout the worldwide tattoo community, Chris Garver garnered mainstream attention after appearing as a regular on the reality-TV show *Miami Ink*. A native of Pittsburgh, PA, he attended the Pittsburgh Creative and Performing Arts High School and later, New York's School of Visual Arts. An avid traveler and aficionado of all styles of tattoos, Chris has visited and worked in such locales as Japan, Singapore, England, and the Netherlands. He is the author of the acclaimed *Color Odyssey*; this is his second book. Chris currently resides in Brooklyn with his daughter.

Get Creative 6 is an imprint of Mixed Media Resources
19 West 21st Street, Suite 601, New York, NY 10010

Flash: Coloring in the Tattoo Style
ISBN: 978-1-942021-52-0

Chris Garver photo by Butch Hogan Photography, www.butchhogan.com
Tattoo photos by Chris Garver
Flash photo by Marcus Tullis

Printed in China

15

First Edition

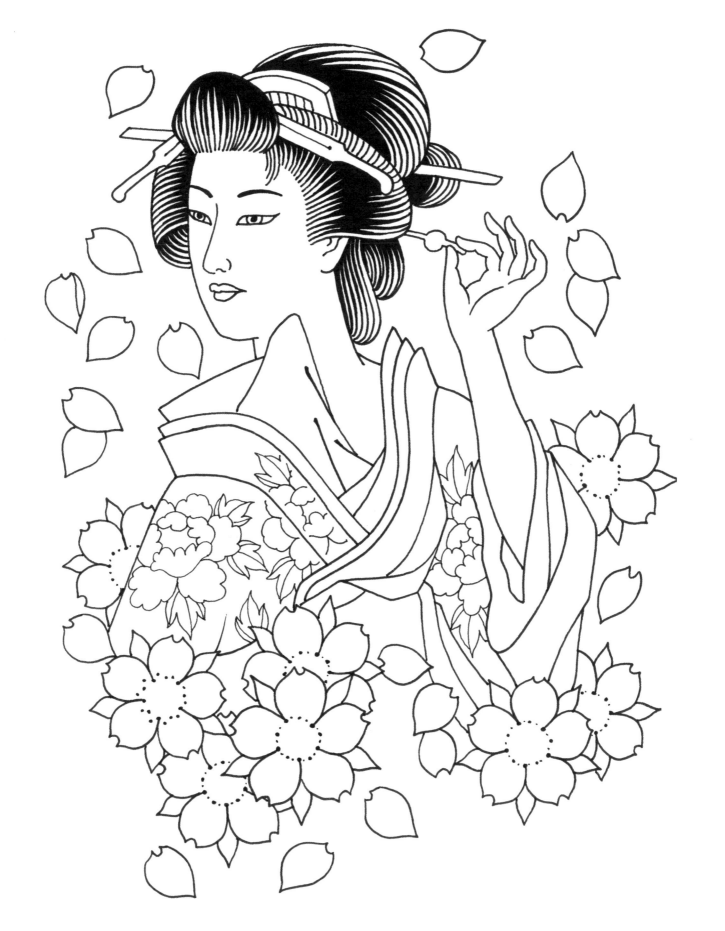

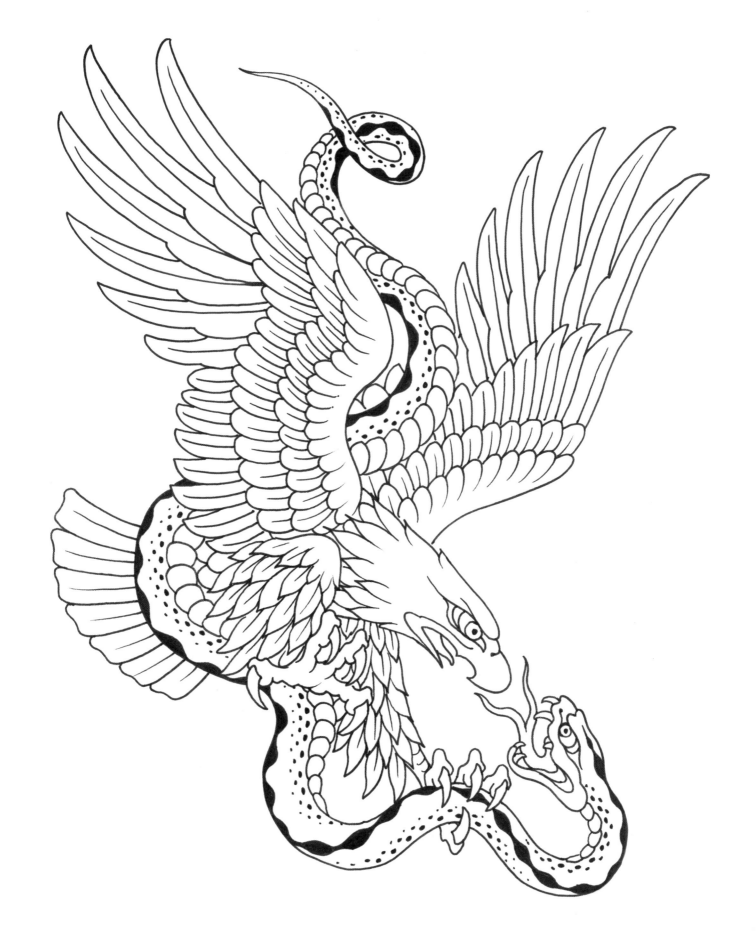

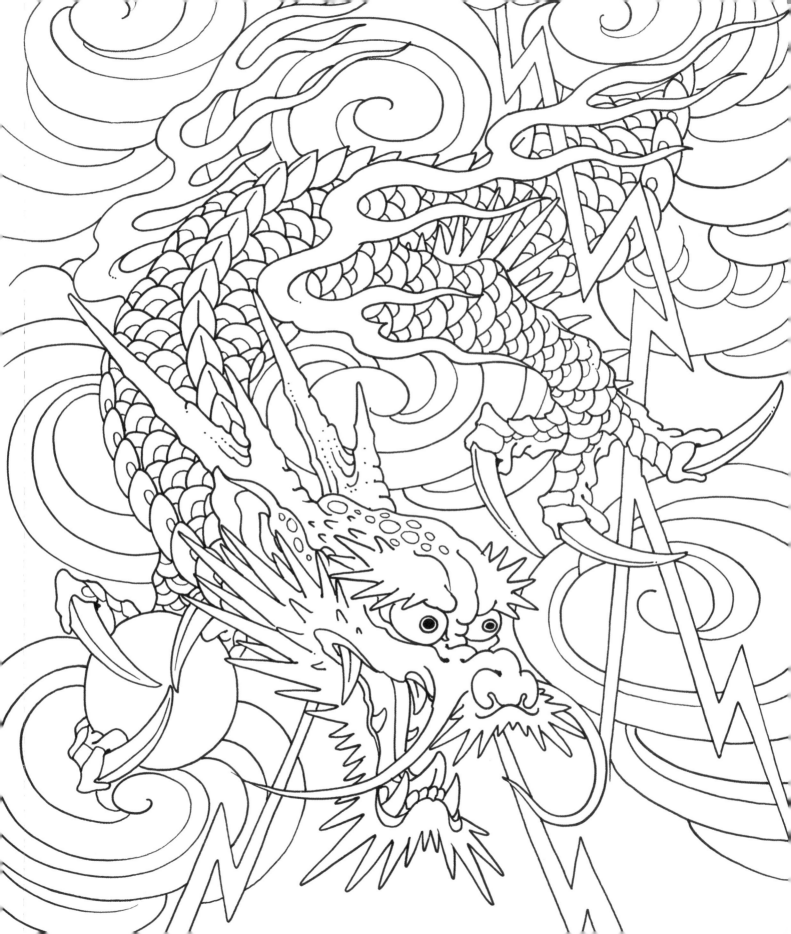

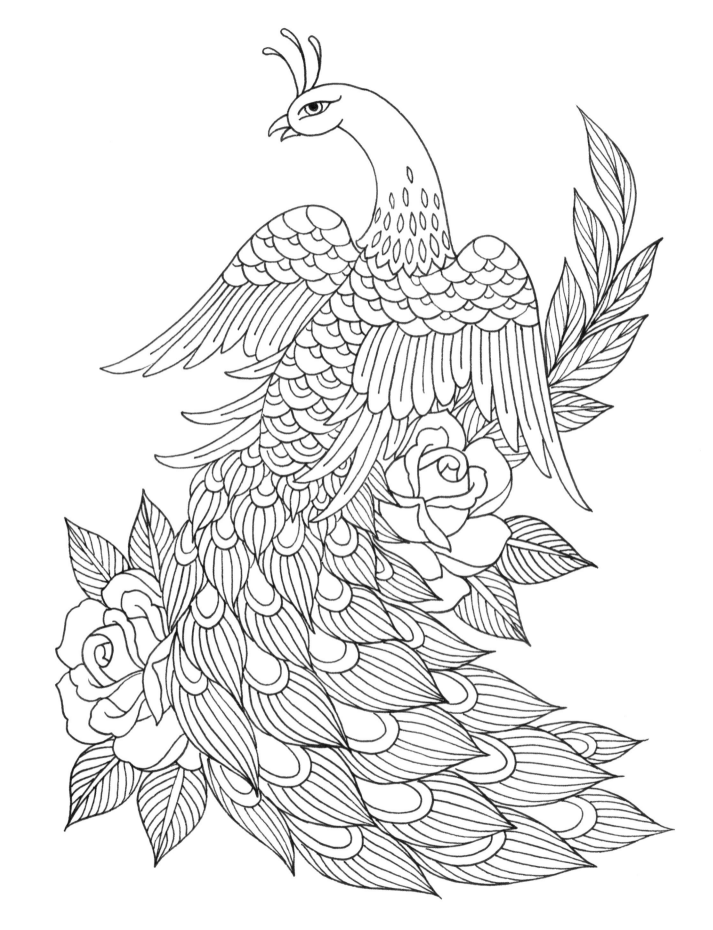

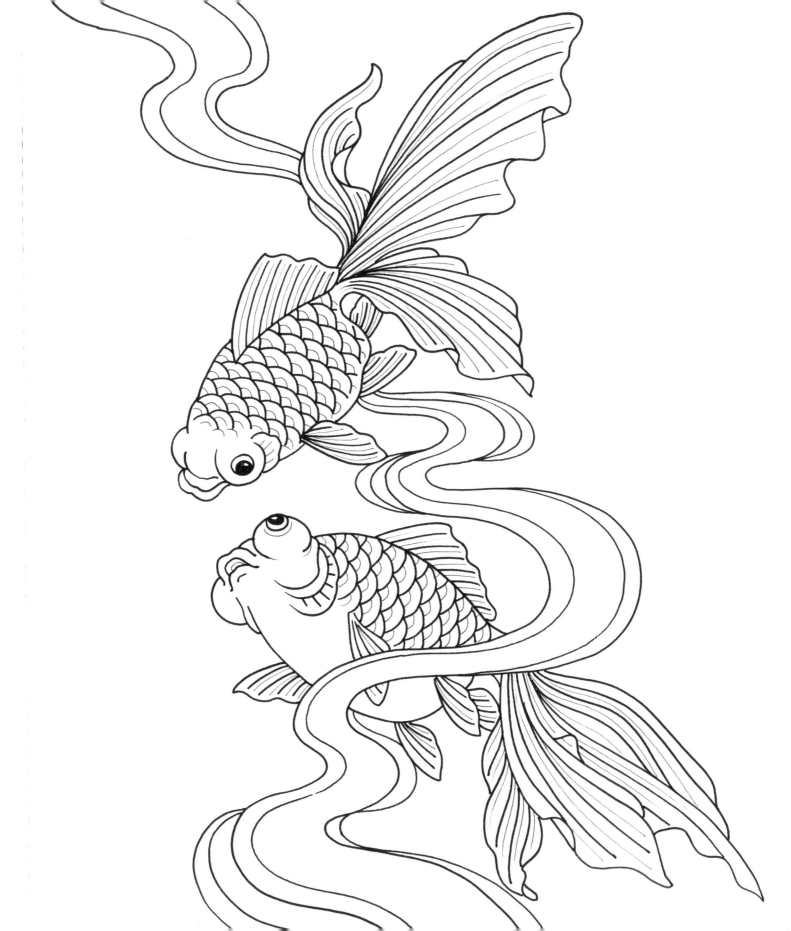

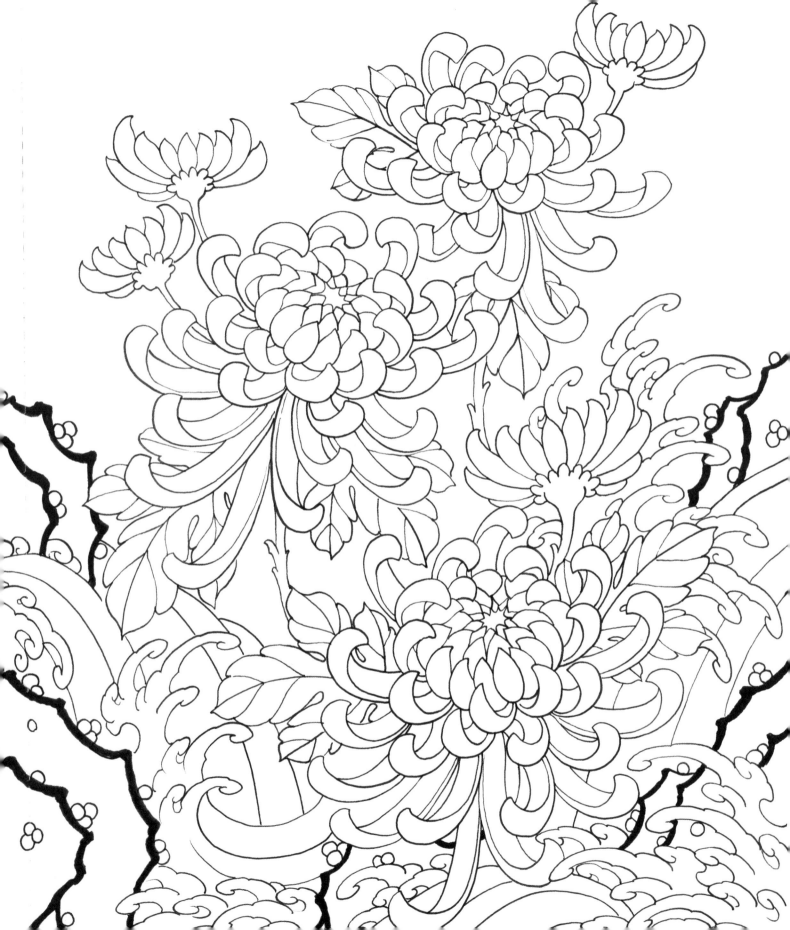

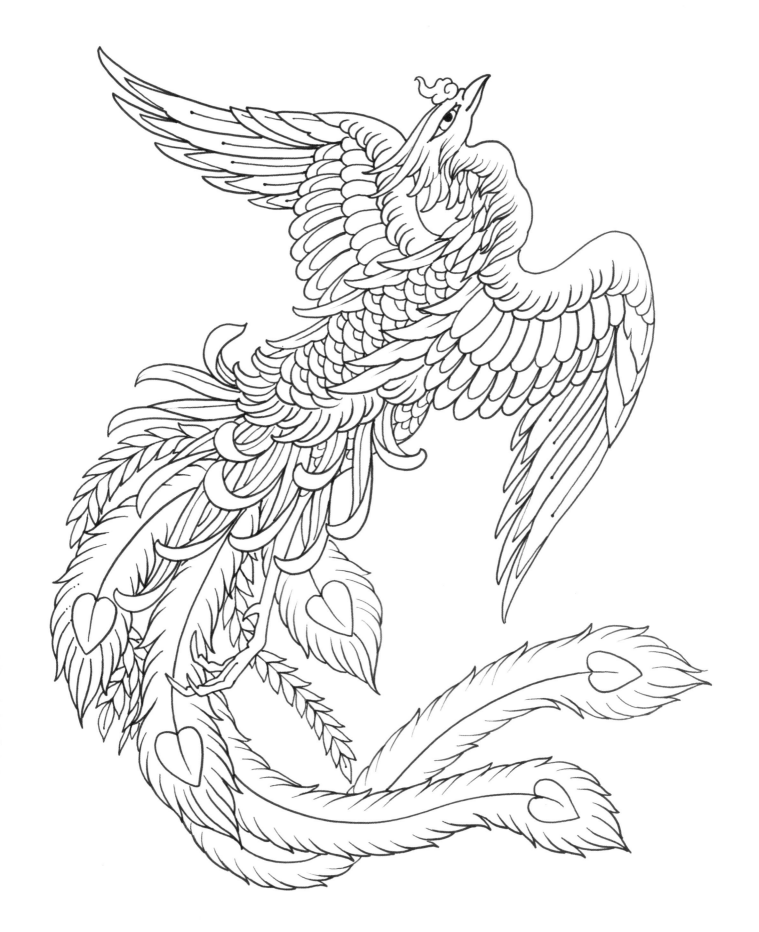

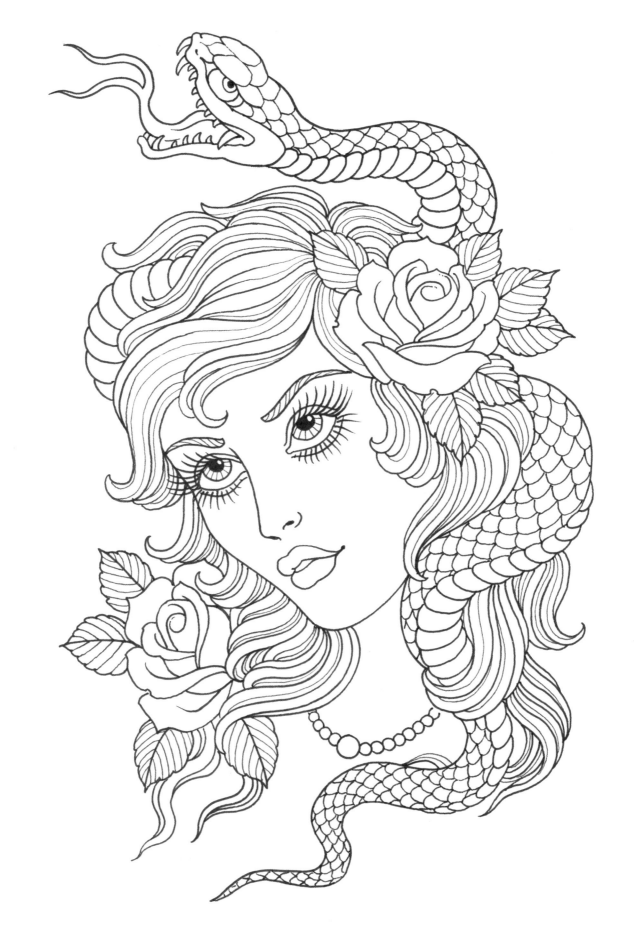

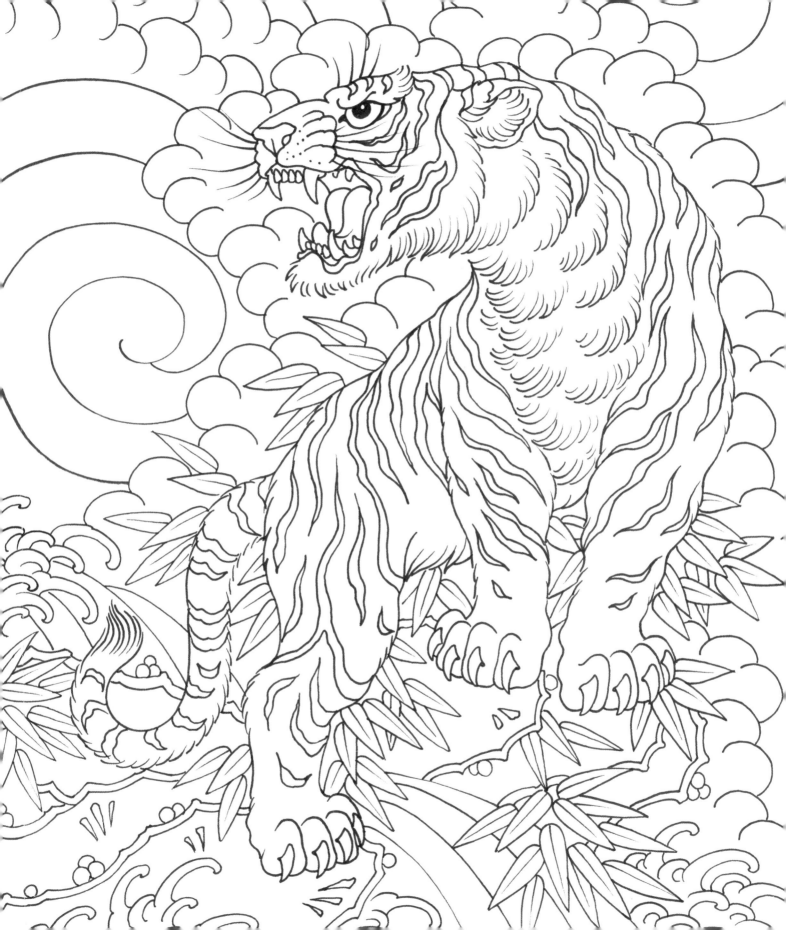

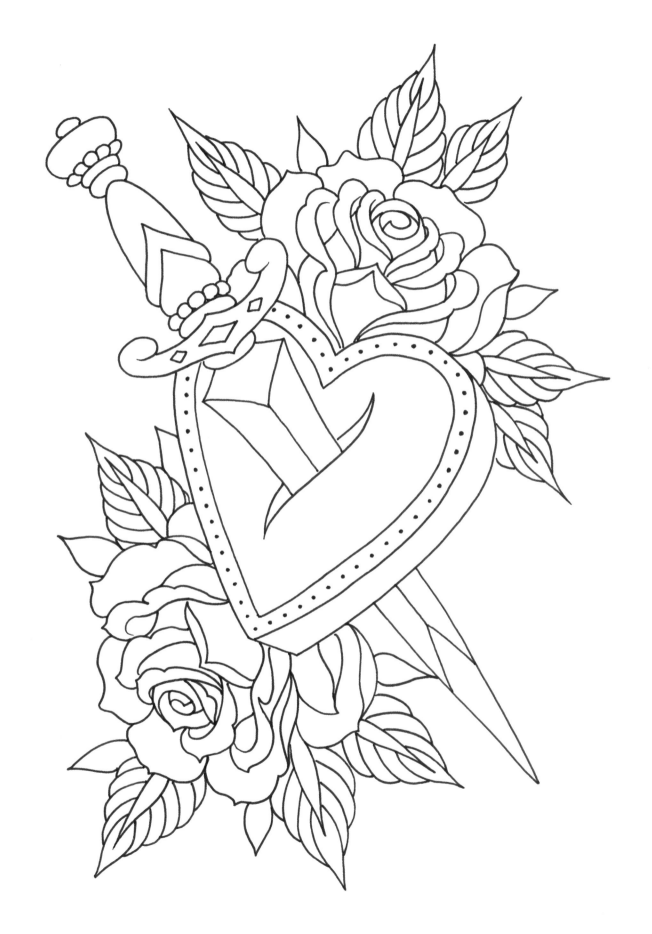

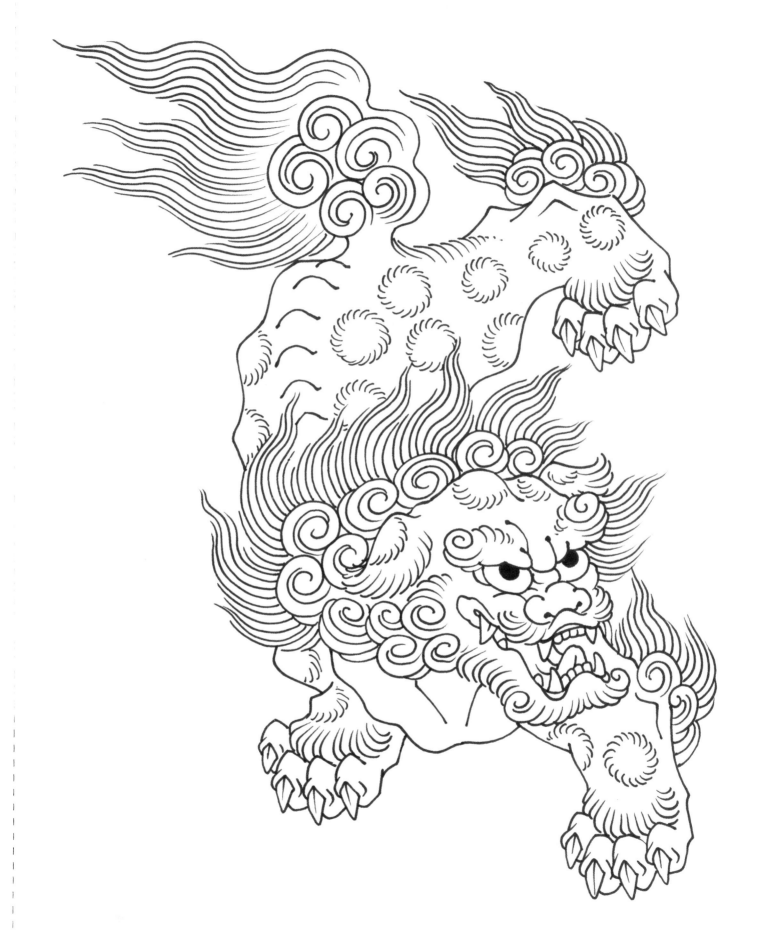

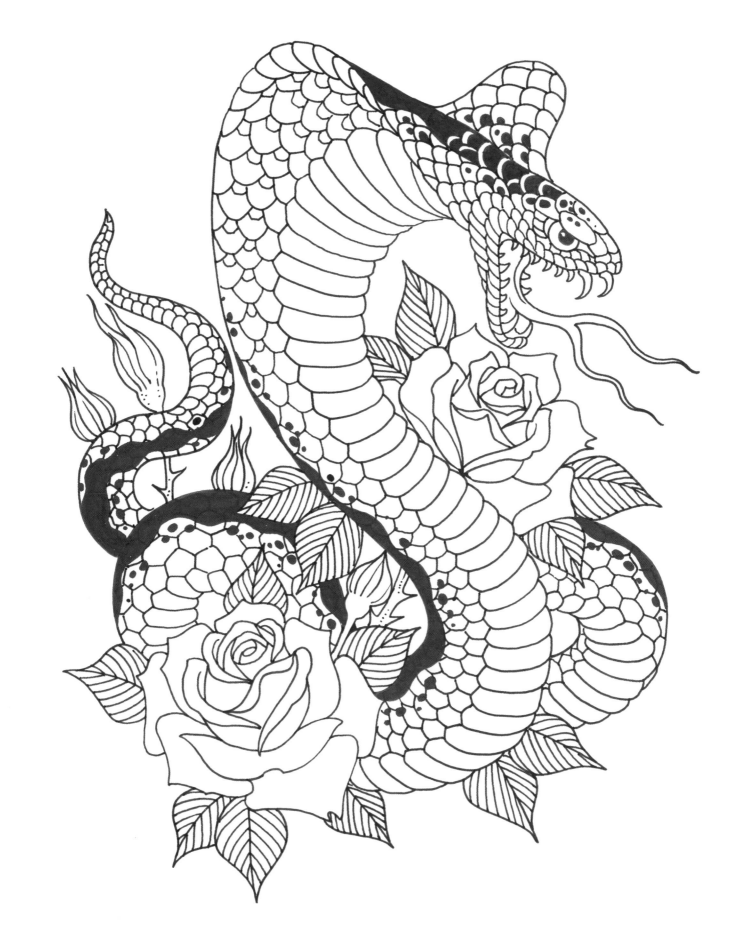

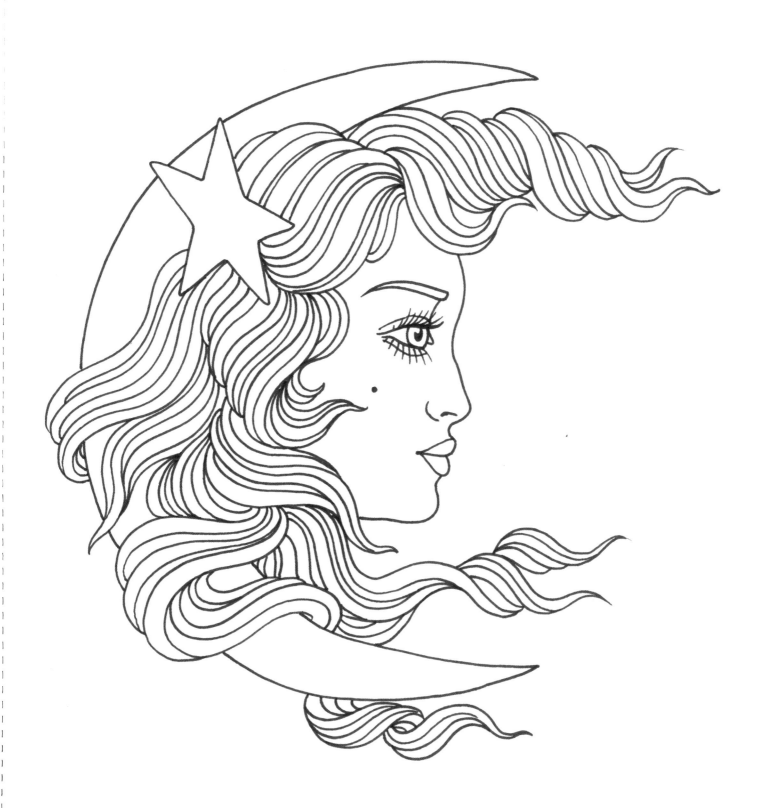

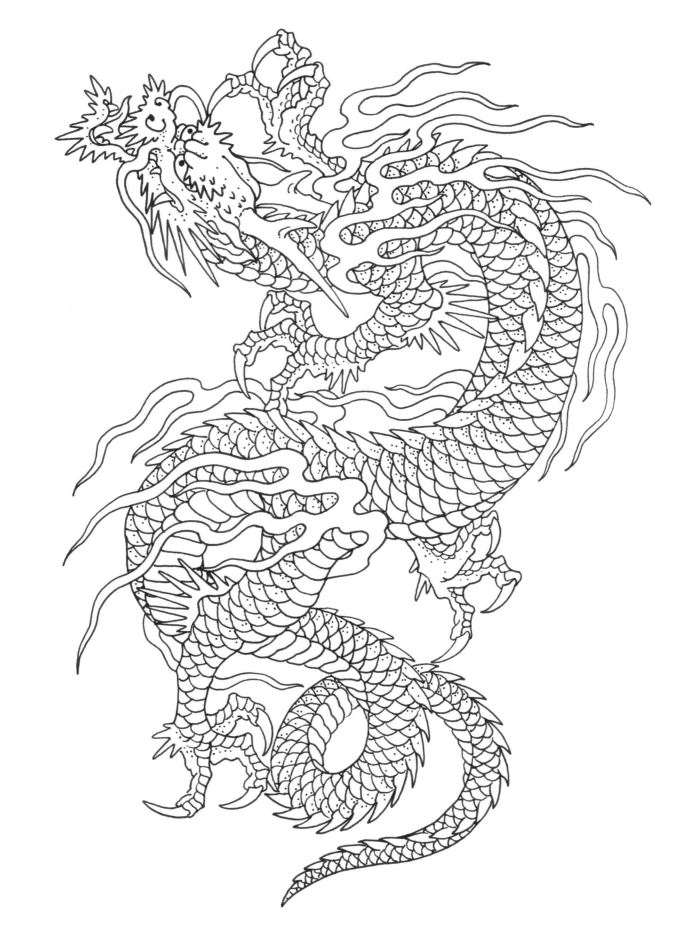

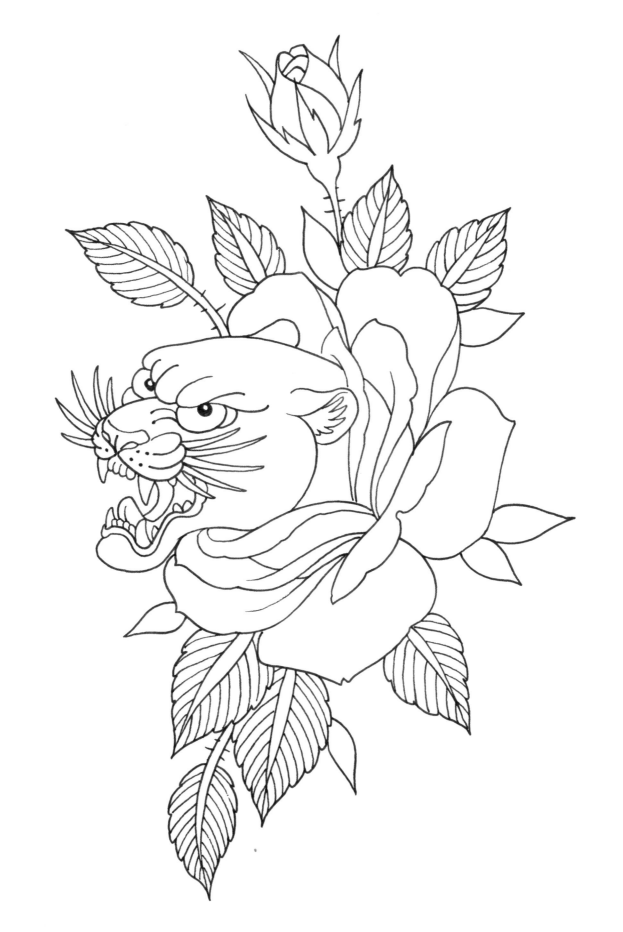

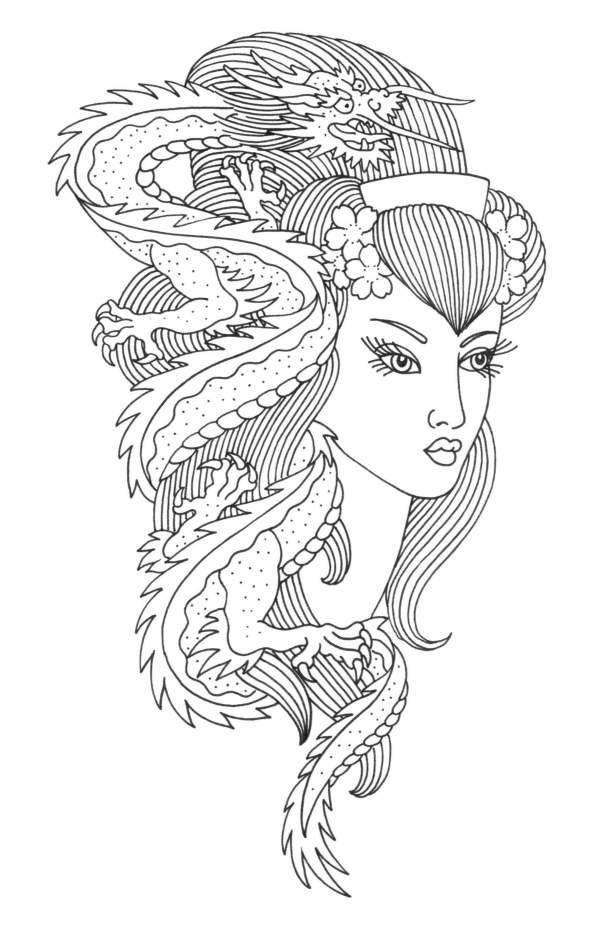

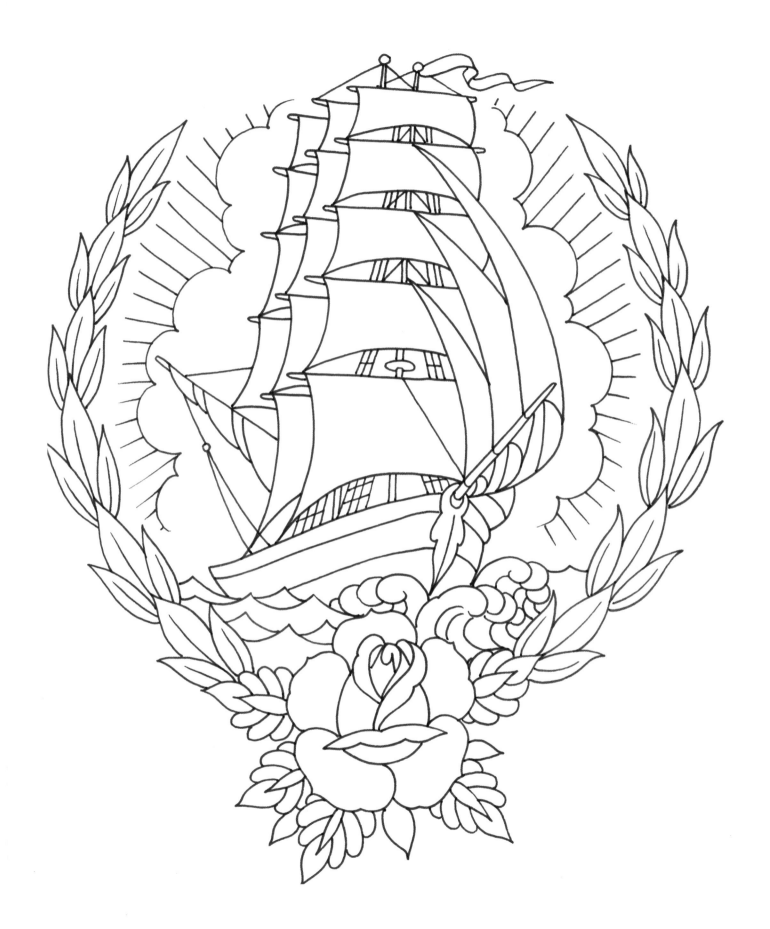

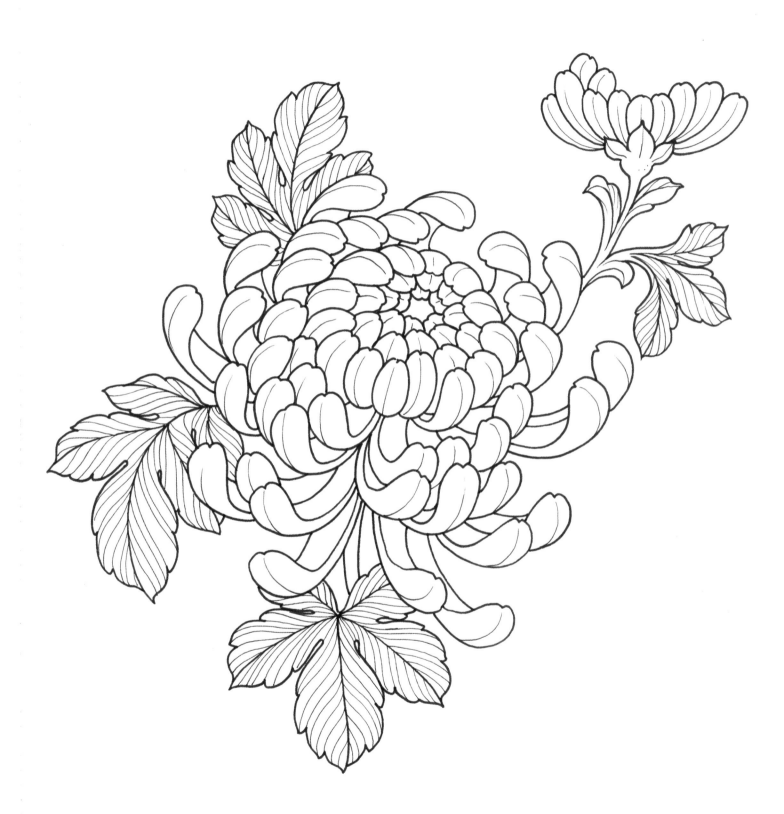

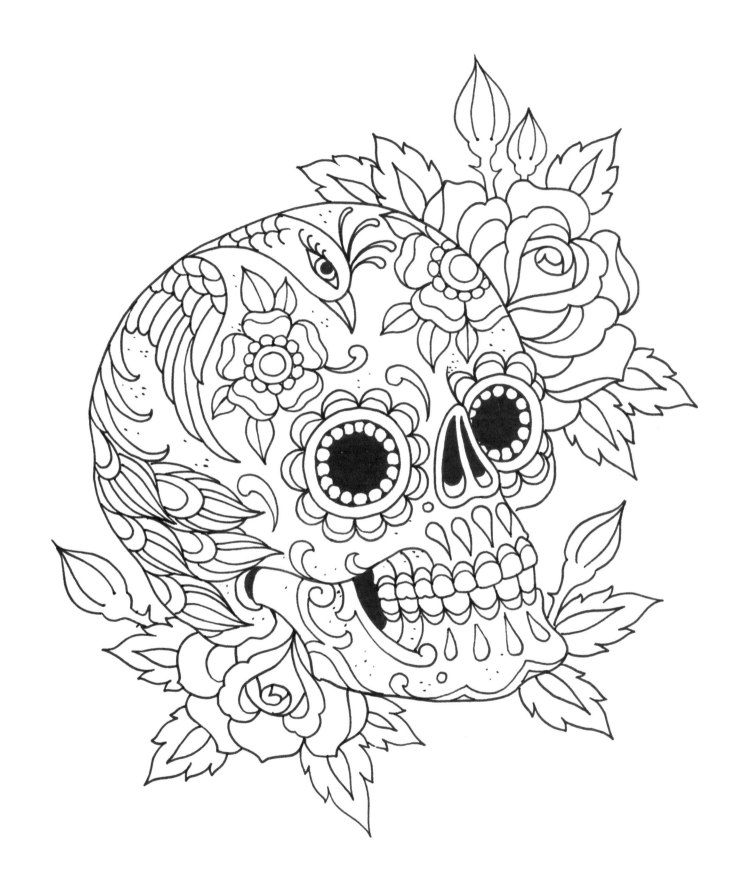

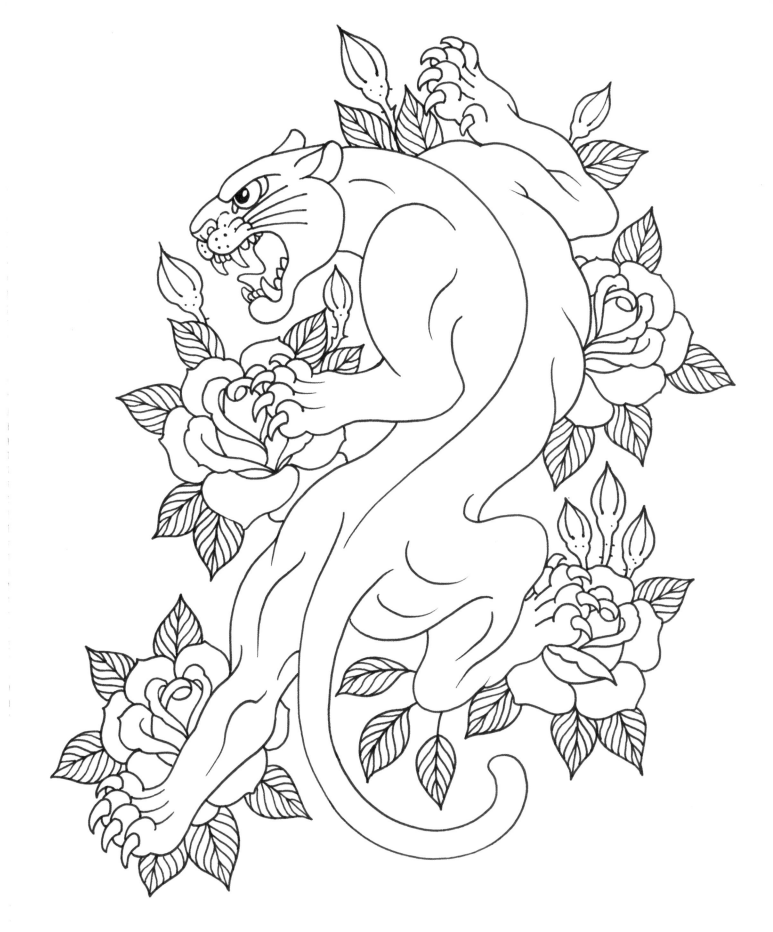

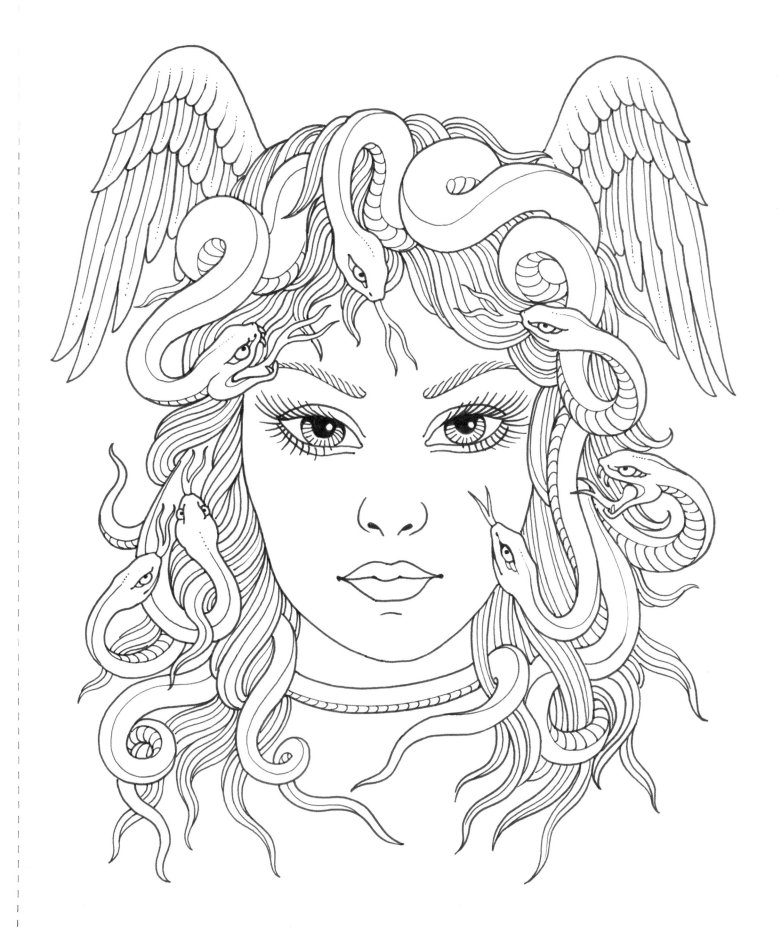

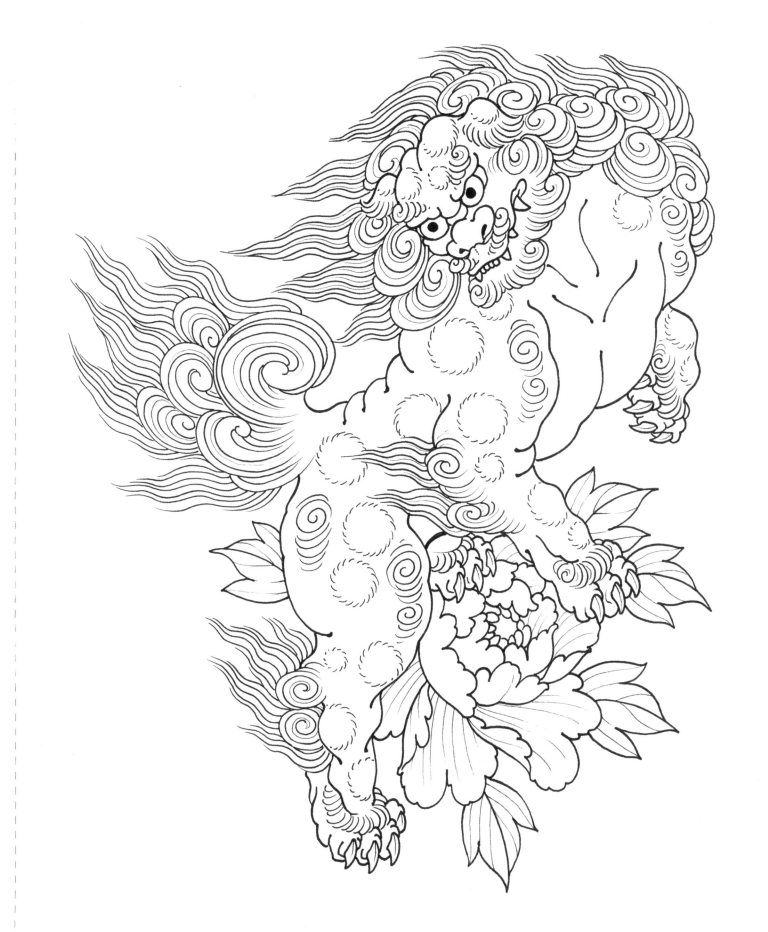

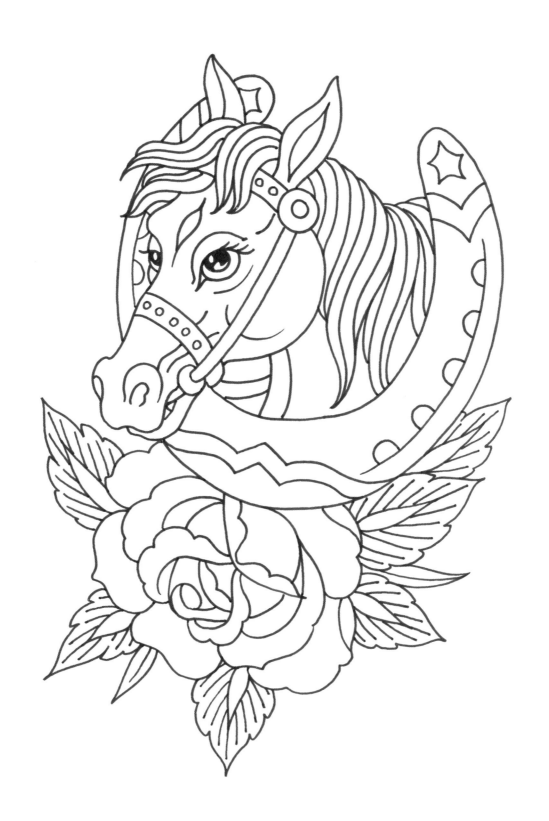

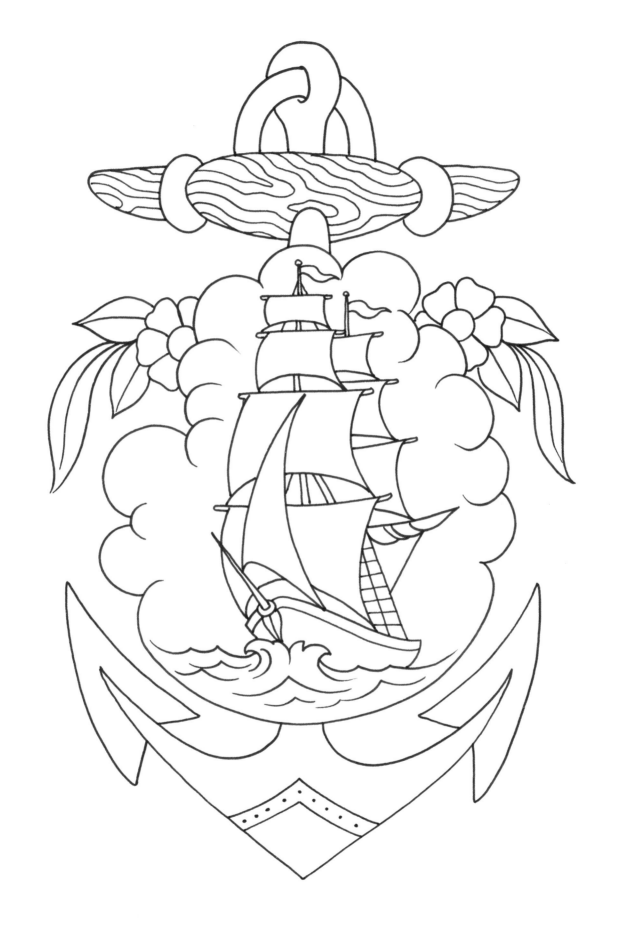

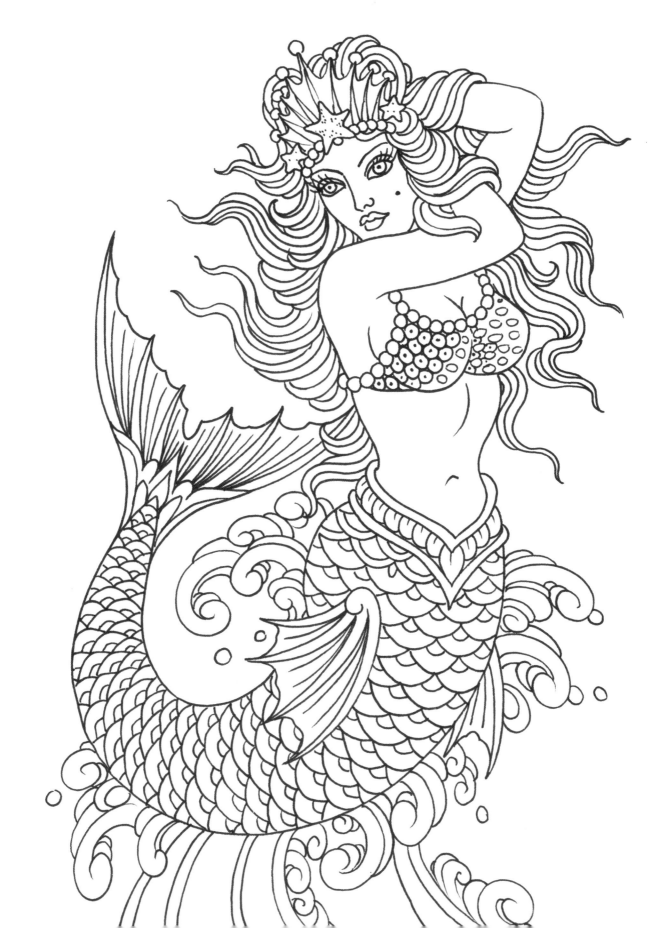

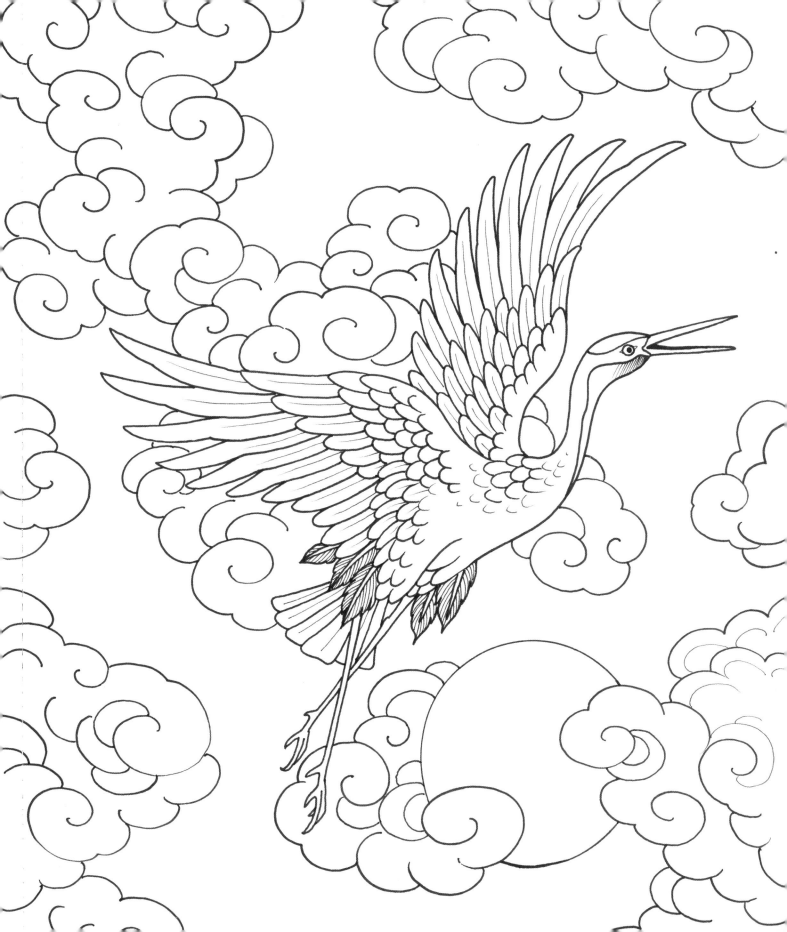

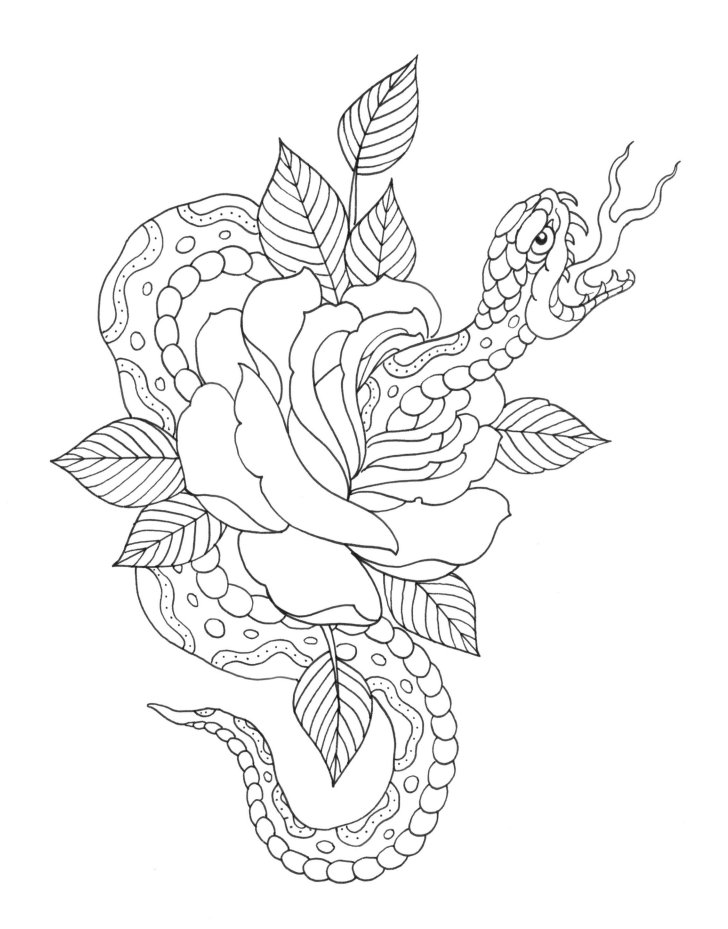

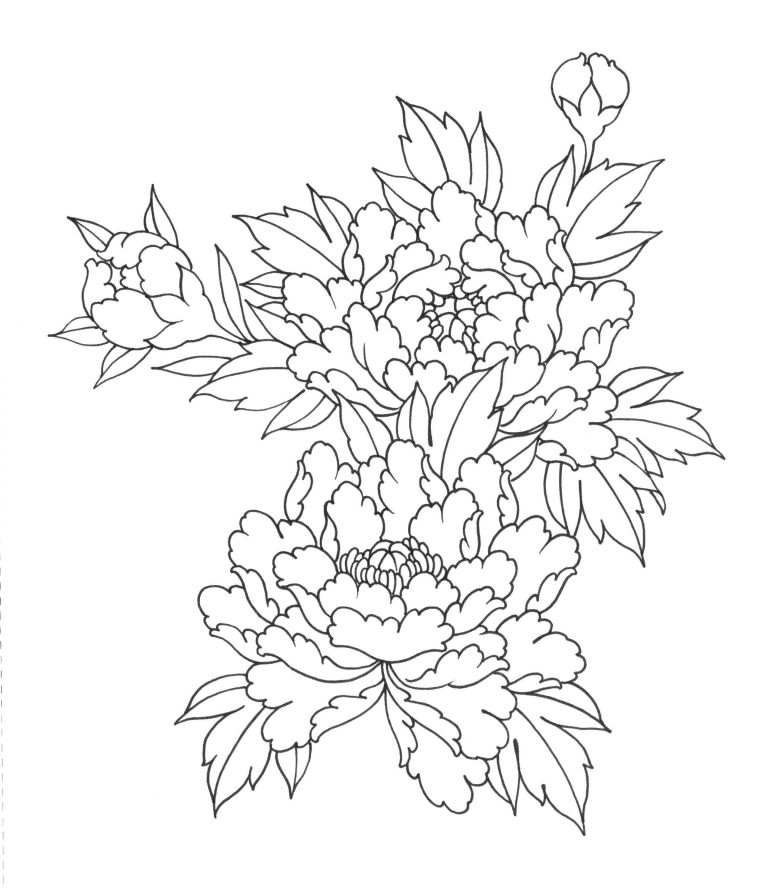

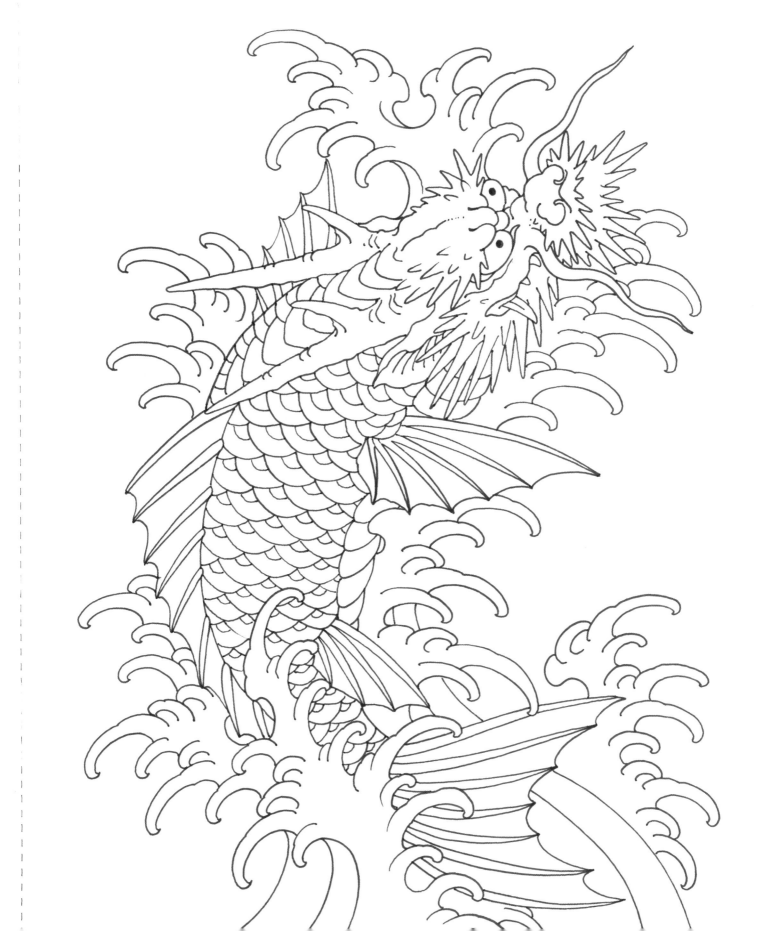

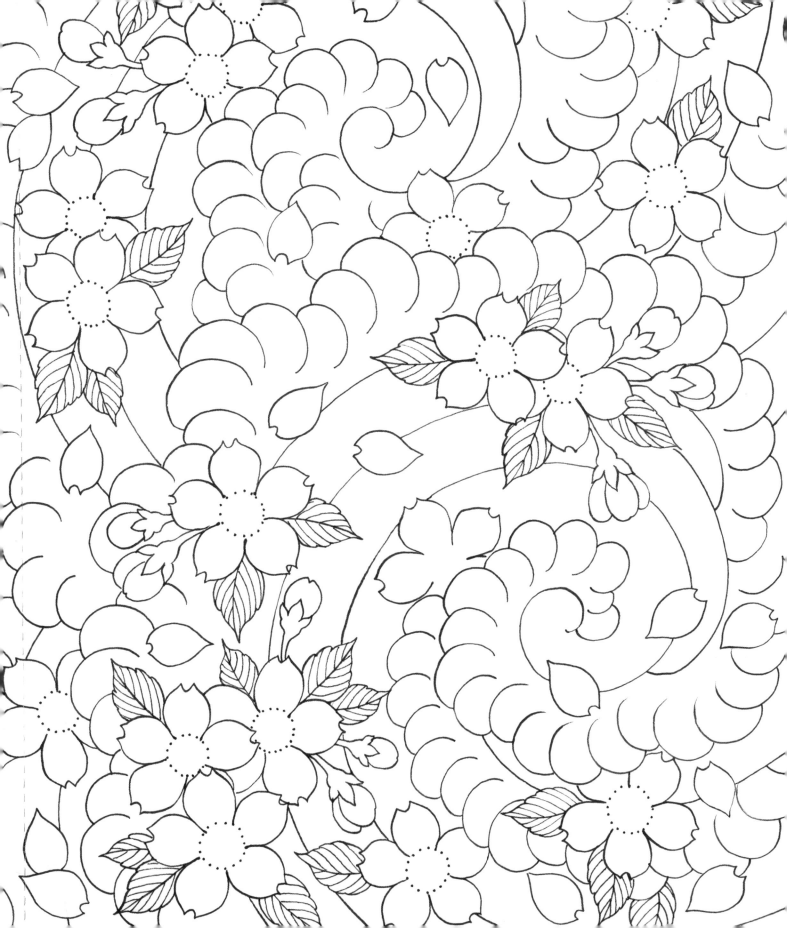

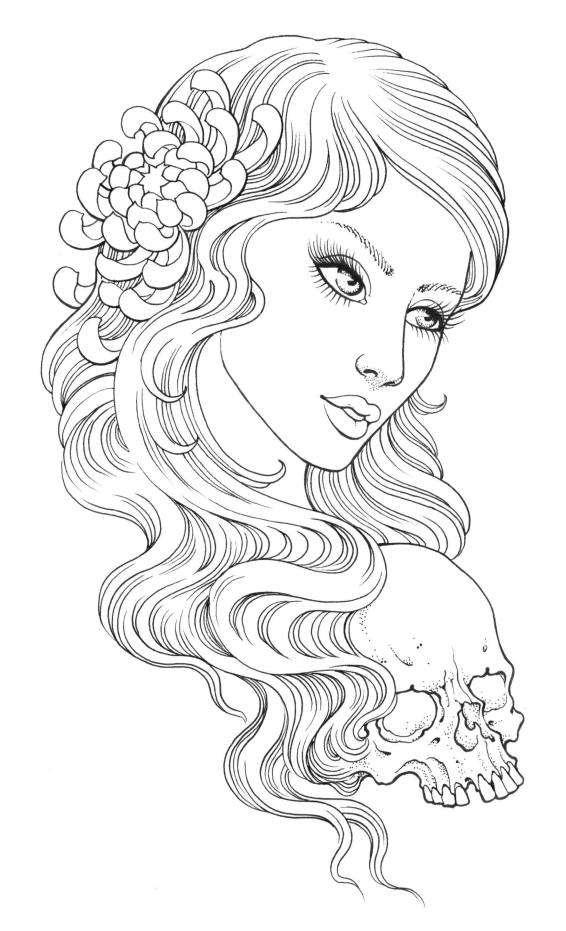

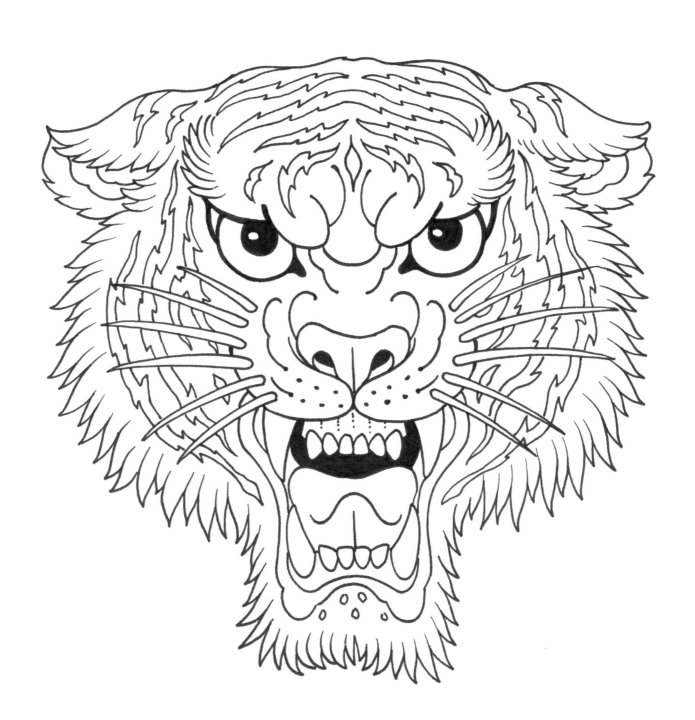

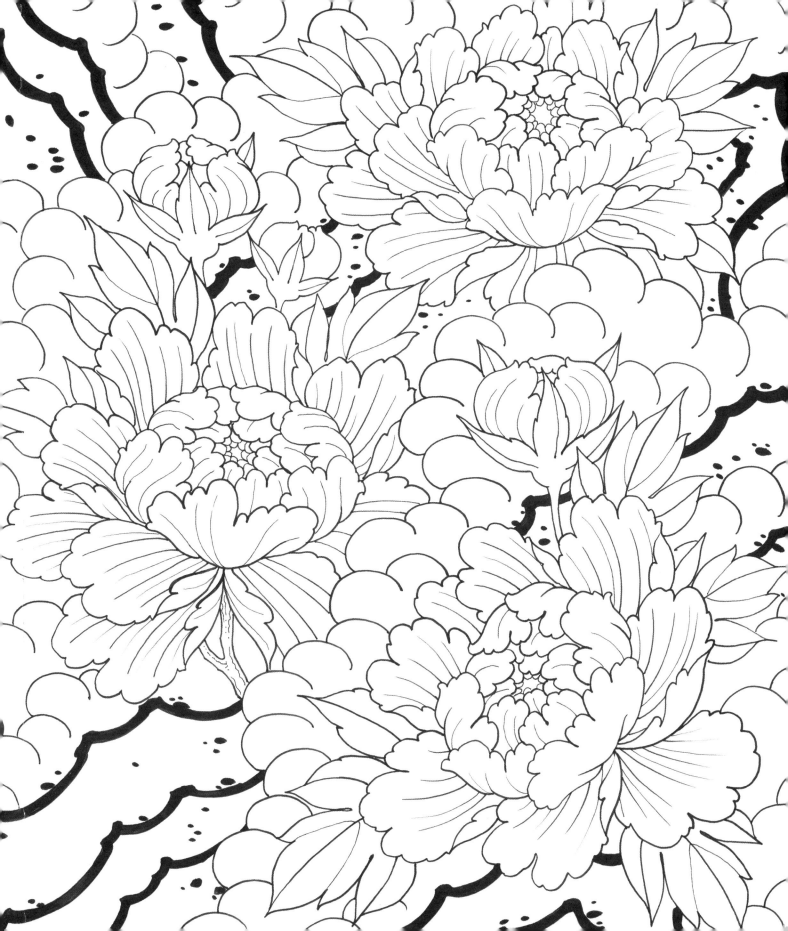

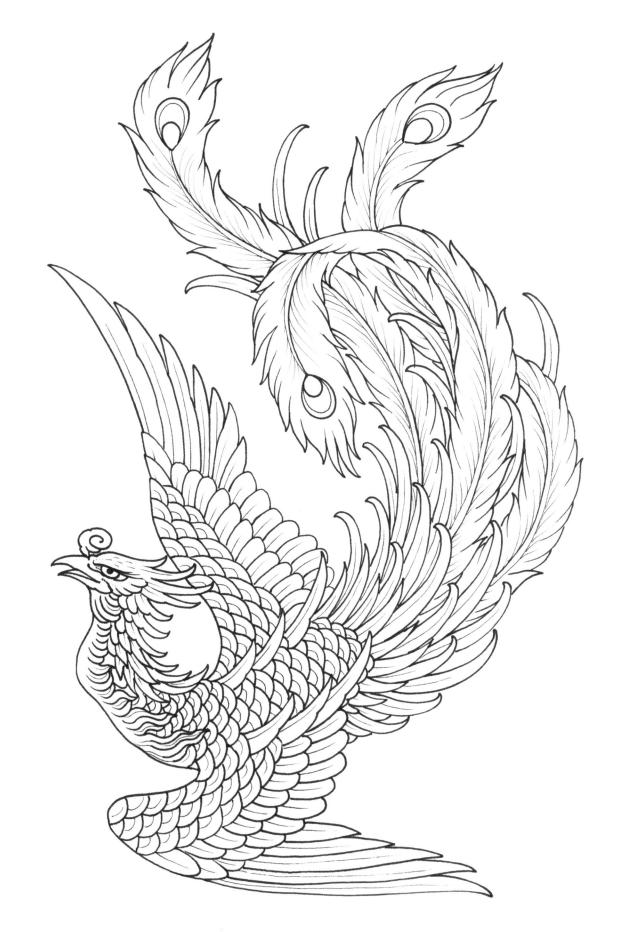

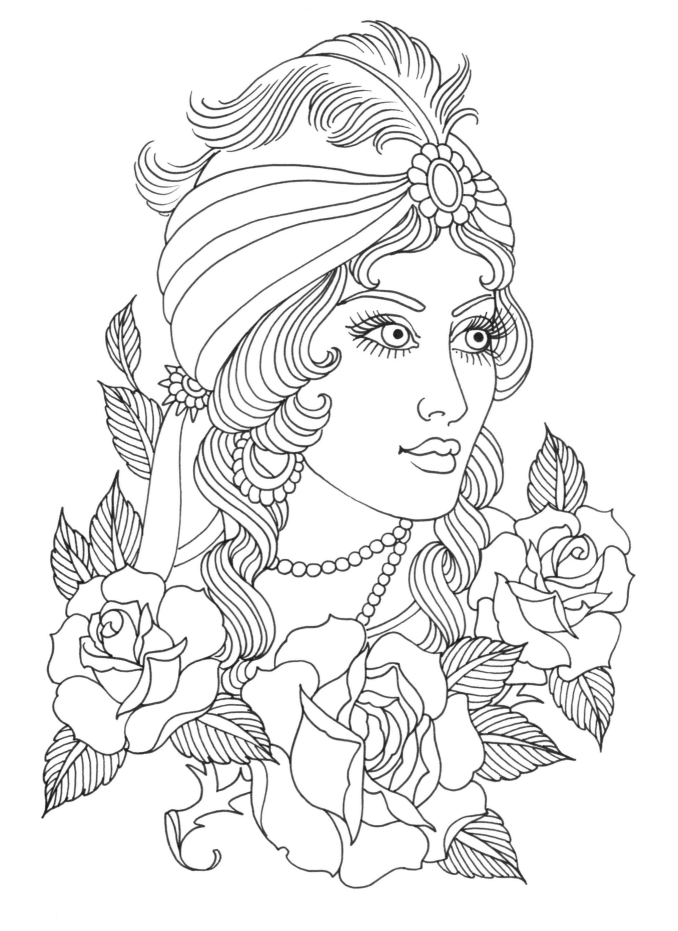

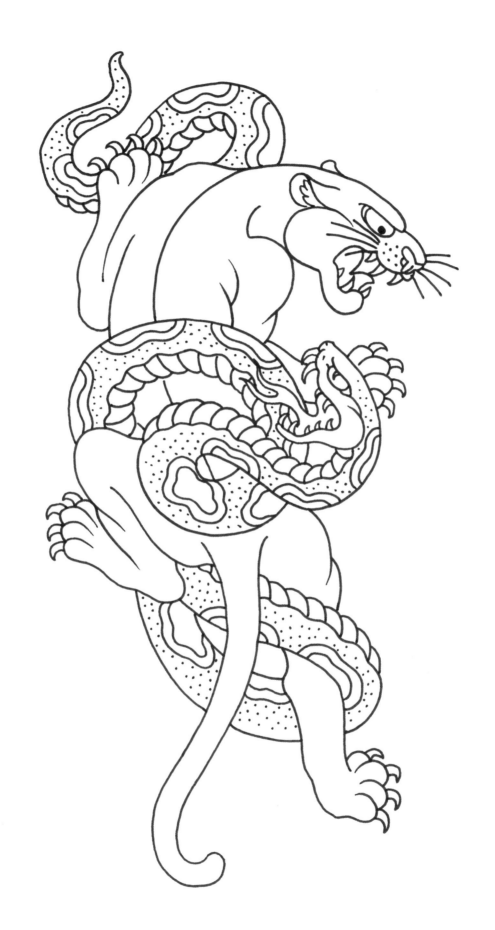

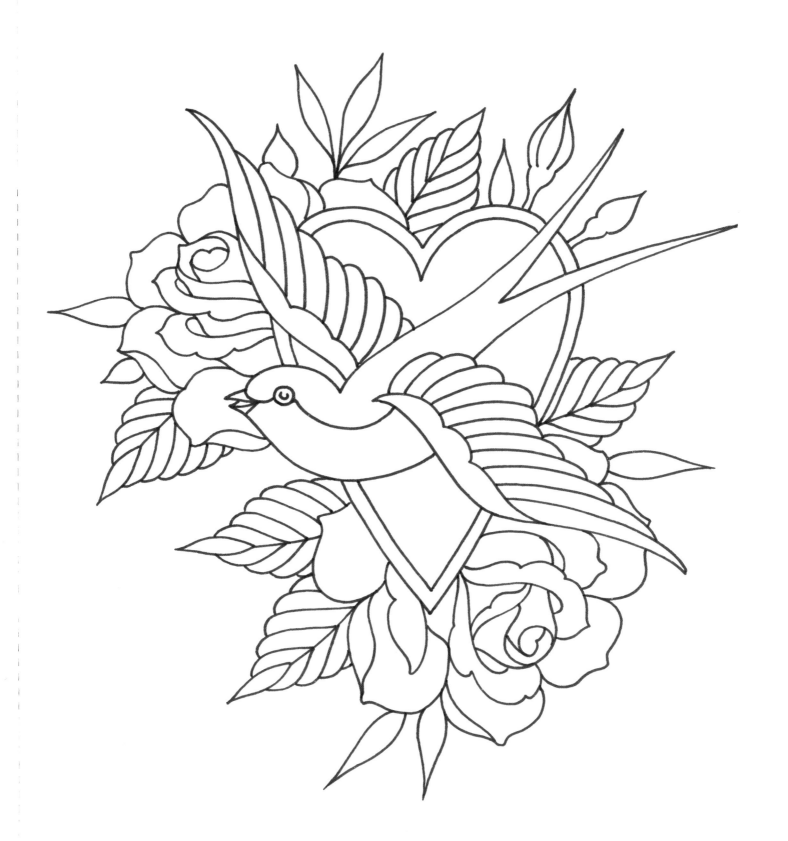

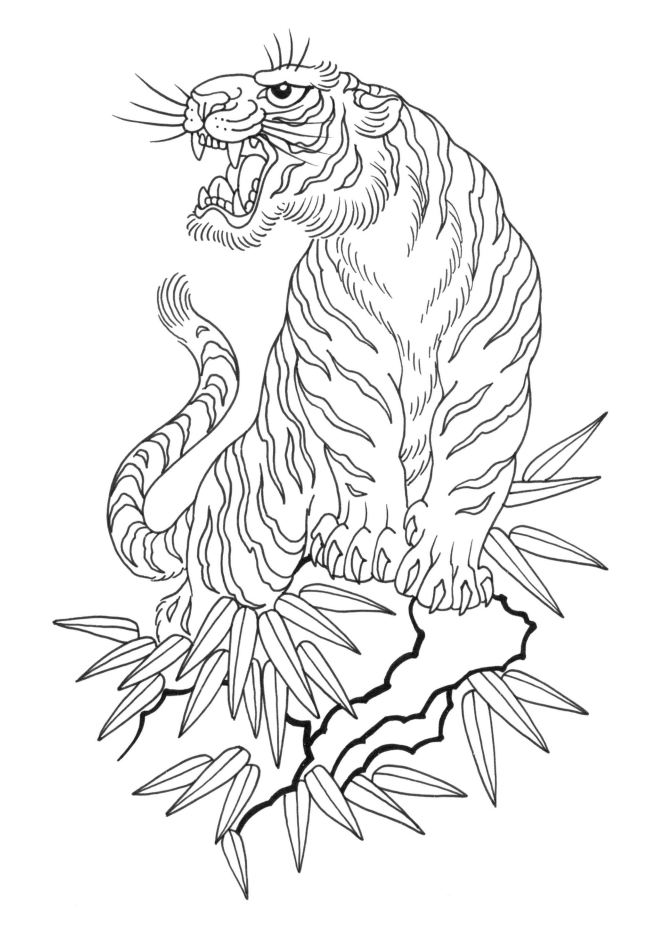

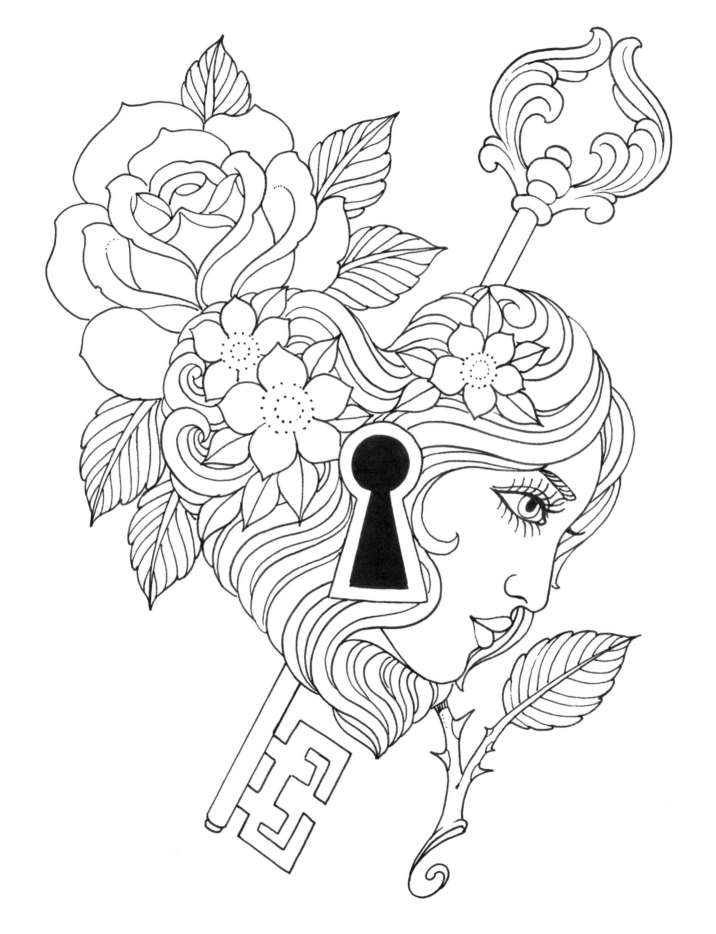

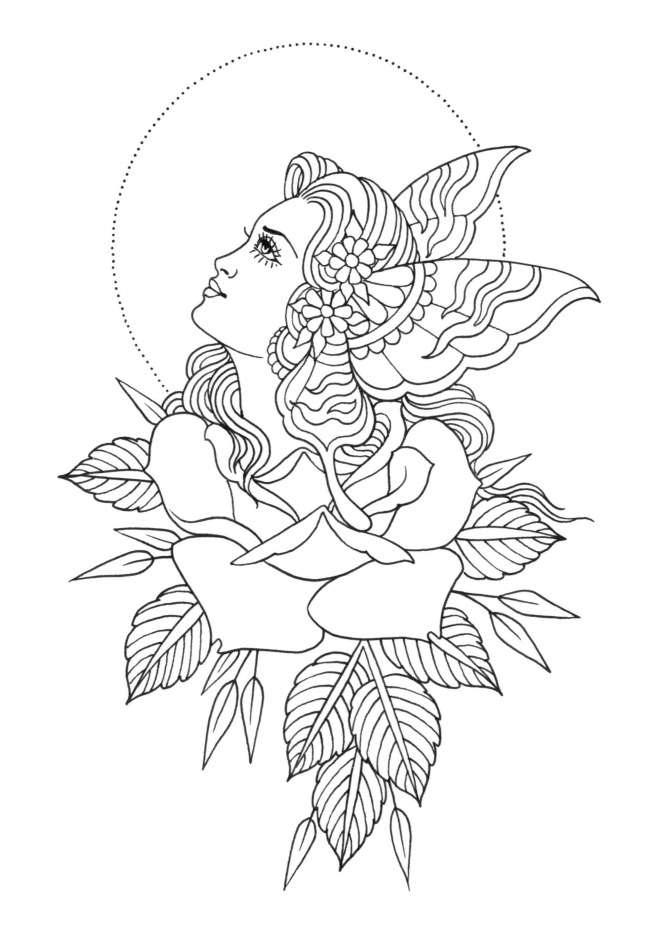

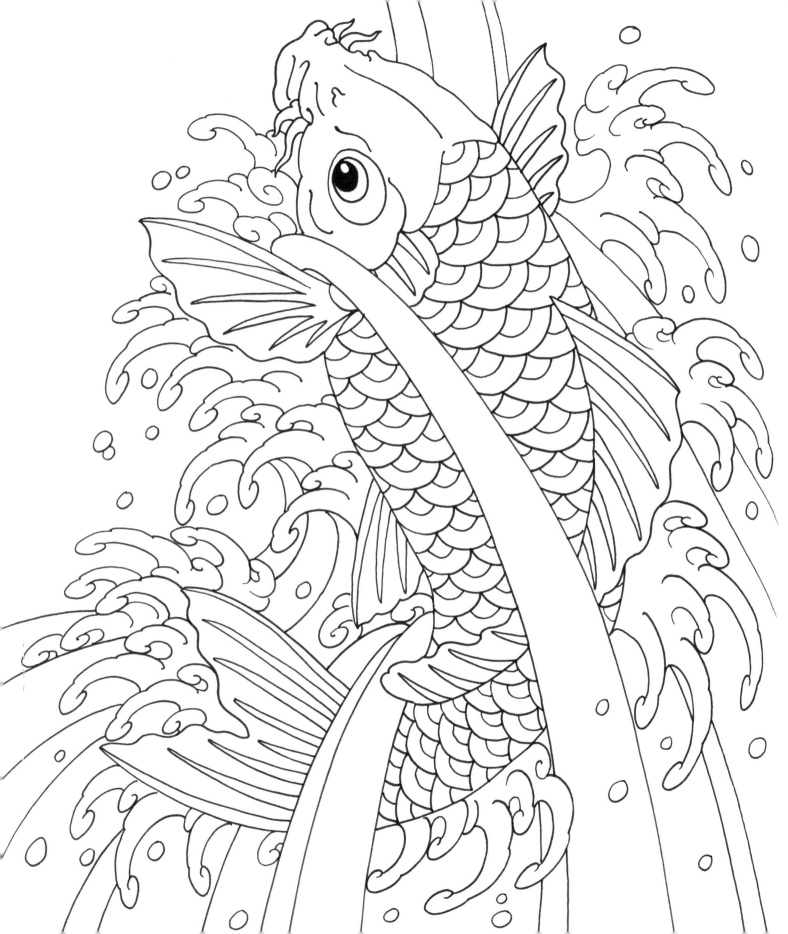

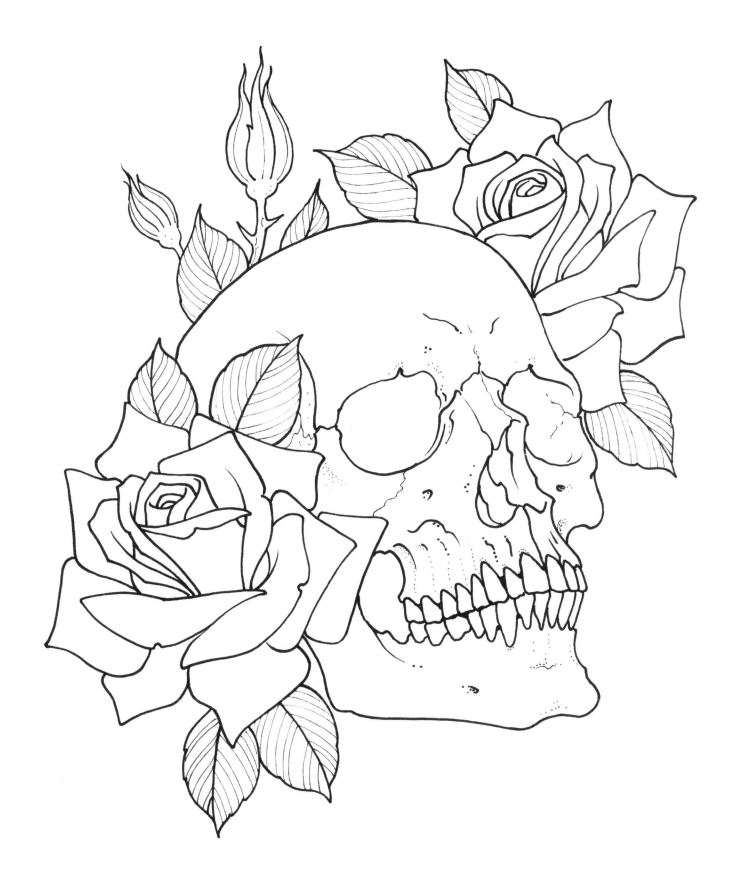

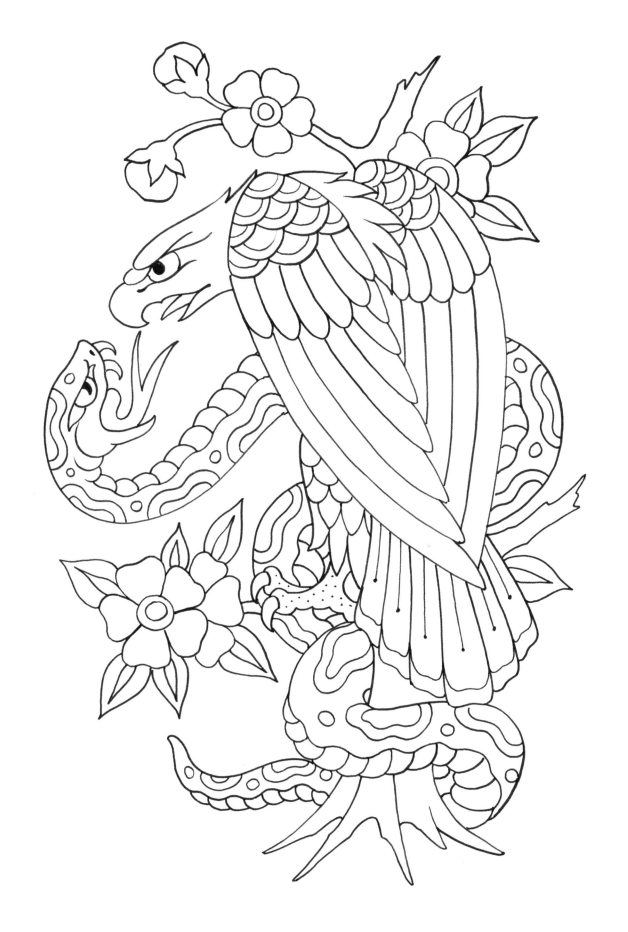

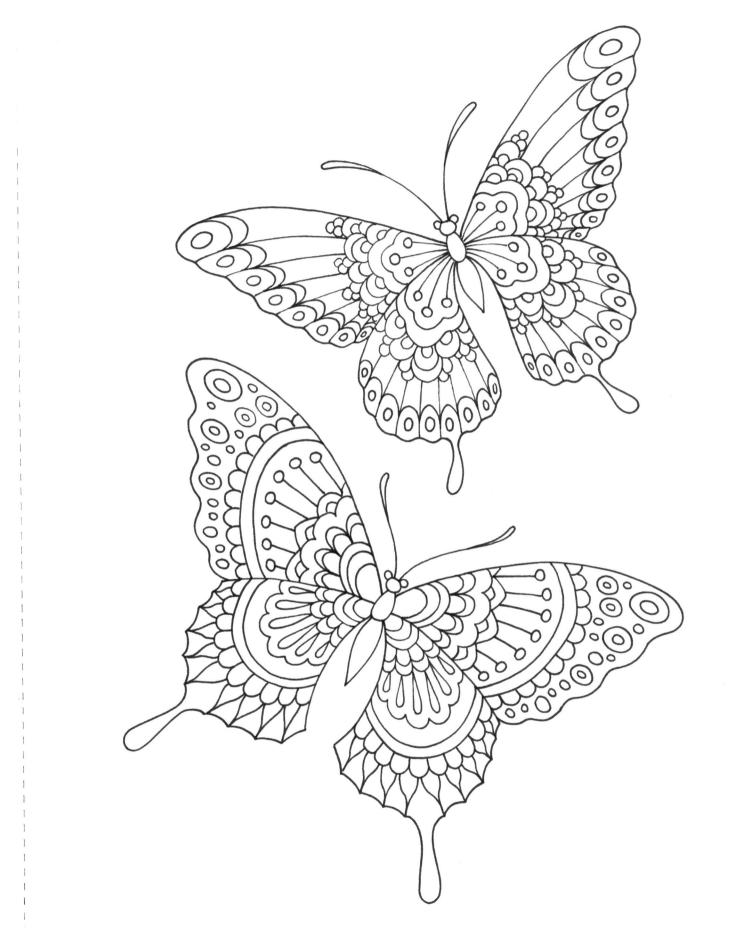

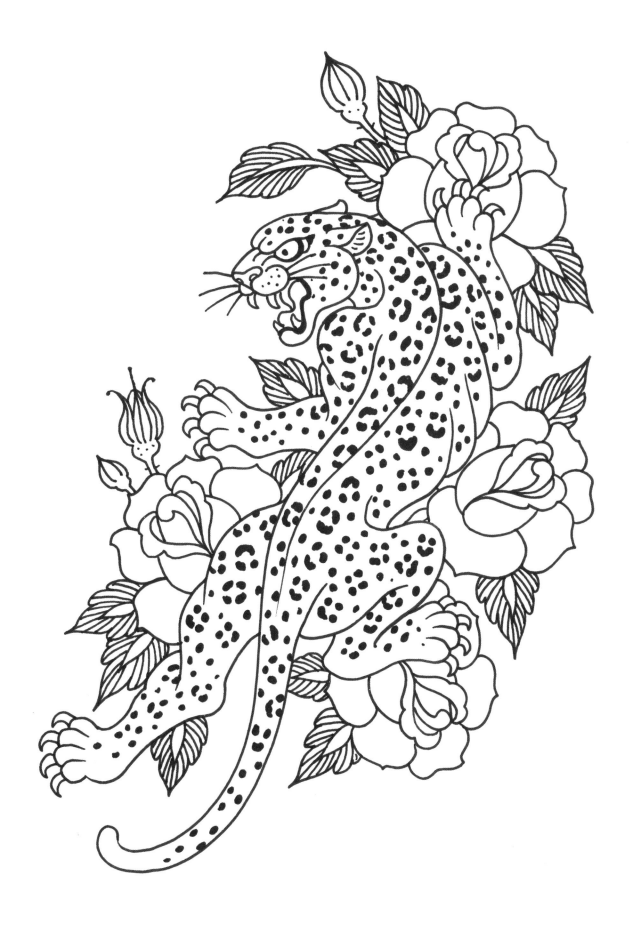